⌜FRAMEABLES⌟

◆

*21 prints
for a picture-perfect home*

Great Outdoors

Flammarion

The Great Outdoors!

Should art imitate nature? Should it strive to equal or surpass it? These are timeless questions. Philosophers, painters, and theorists have debated the issue for millennia. Countless artists have struggled to capture the essence of nature, making it the central focus of their compositions. The harmony and order of the natural world have convinced many that nature constitutes the foundation of beauty and morality. Inspiring a multitude of allegories and interpretations, nature is sacred because it sustains artistic creation.

In the seventeenth century, landscape painting assumed the status of a genre in its own right. Nineteenth-century romantics painted scenes from the comfort of their studios, using nature as an indispensable model. Later, the impressionists expressed their vision by painting the natural world directly, working "en plein air" (in the open air) or "sur le motif" (from the theme). This artistic revolution originated in England and spread to the continent in the 1820s. Easels, pastels, pencils, and newly introduced metal tubes of paint were essential tools for these artists, who embraced the outdoors as their atelier. Paul Cézanne, a master of the technique, wrote to Émile Bernard in 1904, "I spend every day in the countryside . . . pictures painted inside, in the studio, are never as good as those painted en plein air."

In the twentieth century, a contrarian avant-garde questioned the relationship between art and reality, rejecting the notion of art as imitation. Instead, it is the artist's own inner nature that is expressed on canvas or paper. This collection of landscapes reflects a broad range of pictorial techniques and demonstrates the interplay and influences of various artistic movements. Nature continues to exert an irresistible power over artists, commanding their attention and driving their creative expression.

P. B.

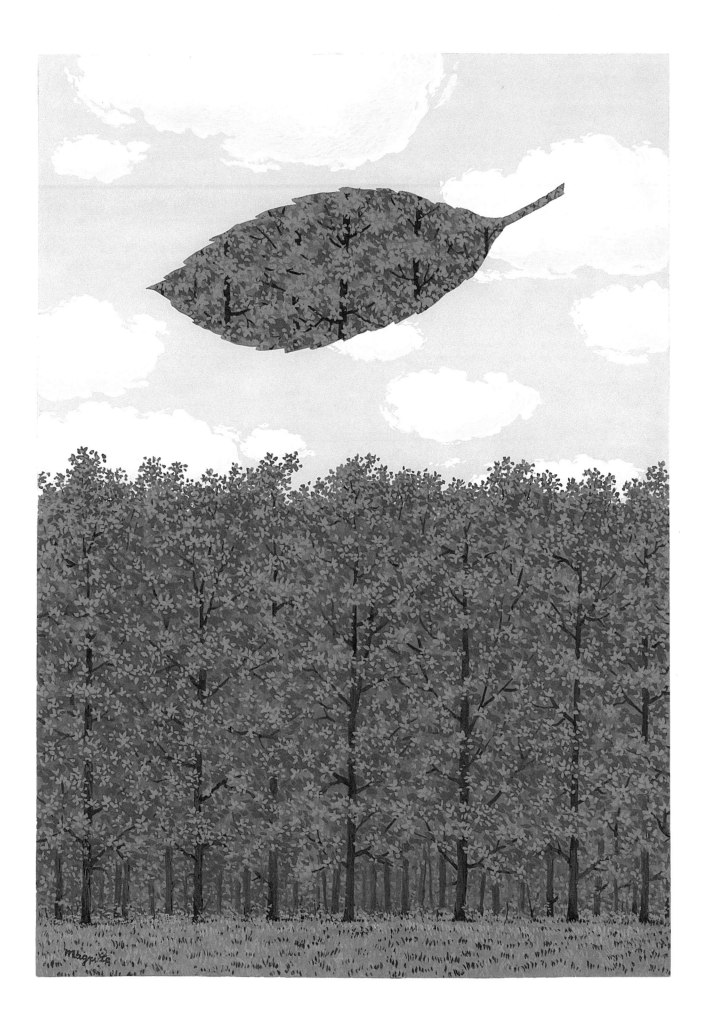

1964

René Magritte

Chorus of the Sphinx
Gouache on paper
16 × 11¼ in.
(40.5 × 28.7 cm)
Private collection

Where to See His Works

Art Institute of Chicago, Chicago
Centre Pompidou, Paris
Guggenheim Museum, New York
Los Angeles County Museum
of Art, Los Angeles
The Metropolitan Museum of Art, New York
Musée de Grenoble, Grenoble
Musées Royaux des Beaux-Arts
de Belgique, Brussels
Museum of Modern Art, New York
Philadelphia Museum of Art, Philadelphia

The Work

Magritte's surrealist images challenge our understanding of reality, calling into question the habitual order of our perceptions. In this painting, the artist places the viewer in front of a dark forest, so densely overgrown that no light can penetrate its depths. However, the sky above is a luminous blue, scattered with clouds. Overhead, a gigantic leaf hovers mysteriously. Weightless and disconcerting, it is textured with foliage, a fragment of the forest below. The enigmatic title and subject matter of this 1964 work are reminiscent of an oil painting that Magritte completed a year earlier. Skies, clouds, leaves, and forests are recurrent iconographic themes in his work. Magritte's oeuvre toys with strangely juxtaposed proportions, oddly commingled details, and enigmatic representations. He deconstructs the relationship between objects and reality, and the familiar becomes bizarre.

His Life (1898–1967)

René Magritte, born in Lessines, Belgium, began his career as a commercial artist and designer in a wallpaper factory. He was fascinated by the sense of mystery that emanated from Giorgio de Chirico's metaphysical paintings; Magritte's first surrealist work, *The Lost Jockey*, was strongly influenced by de Chirico. Magritte and his wife Georgette Berger moved to France, where they were welcomed into Parisian surrealist circles and met André Breton. But artistic differences within the group and the economic difficulties of the 1930s soon led Magritte to return to live in Belgium permanently, where he renewed his contacts with the surrealist painters he had worked with earlier. Magritte's works are distinguished by the relationships they suggest between words and images. The ironic wit and strangeness of these paintings arise from the disparity between objects and their representations. Magritte's work features recurring motifs and reveals the influence of the striking compositions that are typical of posters and advertisements.

*Painting
a disorienting reality*

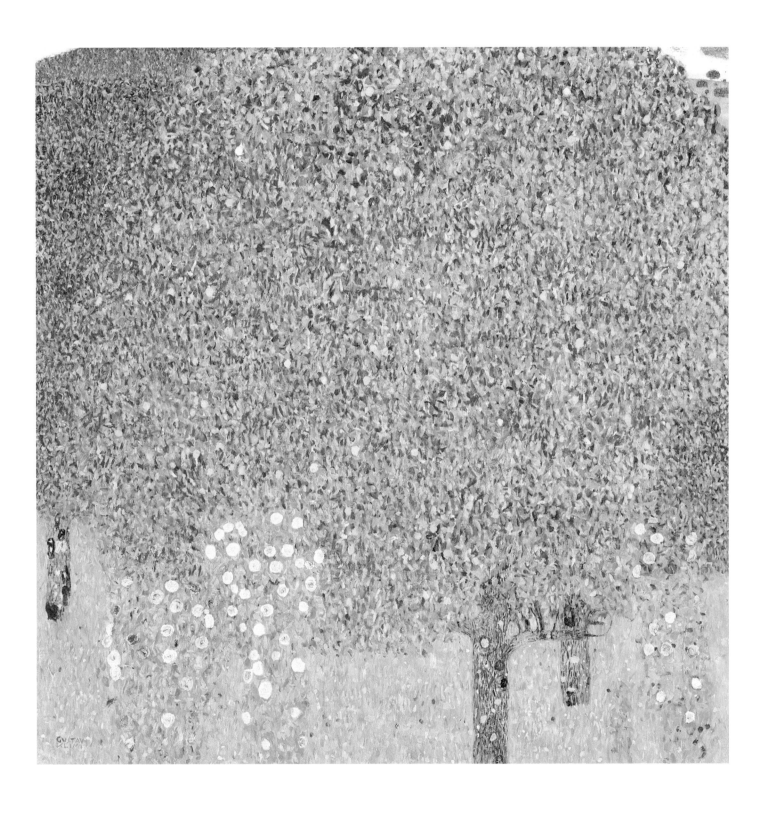

1905

Gustav Klimt

Rosebushes under the Trees
Oil on canvas
3 ft. 7 ¼ in. × 3 ft. 7 ¼ in.
(110 × 110 cm)
Musée d'Orsay, Paris

Where to See His Works

Kunsthaus Zug, Zug, Switzerland
The Metropolitan Museum of Art, New York
The National Gallery, London
Neue Galerie, New York
Upper Belvedere, Vienna

The Work

In the early 1900s, Gustav Klimt began painting in the open air, depicting the changing seasons. He was developing a fresh palette that featured brighter, livelier colors, and he began to paint landscapes in a square format. This work was completed while he was vacationing in Litzlberg in Upper Austria. The viewer's eye is initially drawn to the small, brightly colored brushstrokes in the luxuriant climbing rosebushes; then the gaze is almost overwhelmed by the tiny pointillist dots. Soon there is no longer any stabilizing element in the composition where the eye can rest. Three-quarters of the surface is covered—almost inundated—by the engulfing tide of greenery. The eye instinctively searches for a refuge, as if seeking to escape to the open air that is suggested in the upper corners of the painting. There is a glimpse of landscape and sky in the distance—an opening, providing a reference point for evaluating distances and dimensions. It gives the viewer a refuge within a composition that seems to reject any hint of the void. Influenced by Seurat's neo-impressionism and the distinctive brushwork of Vincent van Gogh and Pierre Bonnard, Klimt deployed the latest artistic advances in these paintings that he called "landscapes."

His Life (1862–1918)

Gustav Klimt was born in Austria to an artistic family: his father was a goldsmith and his mother a singer. Klimt was an eclectic artist who worked in interior decor, design, lithography, and ceramics. He completed *Love*, his first symbolist painting, in 1895. This canvas earned him international recognition and gave him an entrée to Vienna's most palatial residences, whose interiors he designed. In 1897, he founded the secessionist movement, which was embraced by his artistic, intellectual, and philosophic circle. The group advocated a radical break with Austria's academic art, which was losing ground to modern trends inaugurated in Europe with art nouveau. Klimt's early symbolist style incorporated gilt and stylized motifs, but he later produced works influenced by the atmospheric paintings of the Nordic symbolists. He ultimately cultivated a more cheerful aspect of his artistic personality, drawing inspiration from impressionist and pointillist works.

Paintings with stylized decorative details

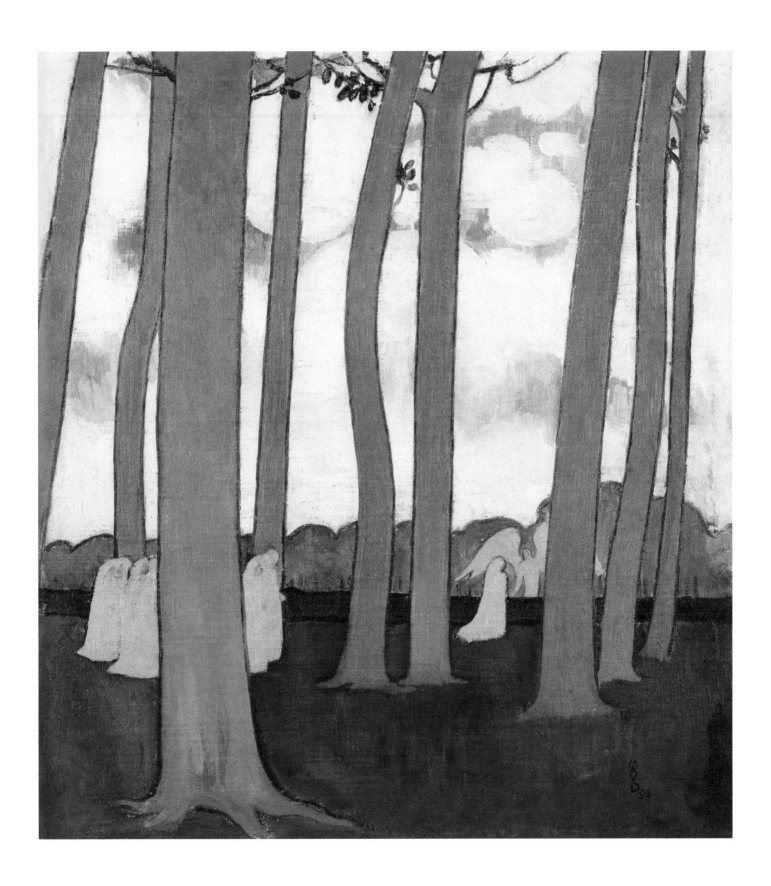

1893

Maurice Denis

Landscape with Green Trees
or *Beech Trees in Kerduel*
Oil on canvas
18 × 17 in.
(46 × 43 cm)
Musée d'Orsay, Paris

Where to See His Works

Guggenheim Museum, New York
The Metropolitan Museum of Art, New York
MUDO—Musée de l'Oise, Beauvais
Musée Départemental Maurice Denis,
Saint-Germain-en-Laye
Musée des Beaux-Arts, Nancy
Museum of Modern Art, New York

The Work

A solemn scene is enacted in a woodland setting beneath towering trees. A silent procession appears in the distance, almost concealed by the tree trunks. One person escapes from the group, a feminine figure who approaches an angel standing apart. They are separated by a barrier, but it does not seem to be insurmountable: it would suffice to step over the low wall that runs across the composition like a horizon line. The procession stands out eerily against the backdrop, which is painted in cool, earthy tonalities. The picture planes are juxtaposed, and the absence of shadows reinforces the impression of flatness. Maurice Denis completed this oil painting on a notable occasion, the year he married Marthe Meurier, which also heralded a new period in his creative life. The distinctive features of his oeuvre are already evident here: broad zones of solid color, simplified forms, a mystical atmosphere, and religious subject matter. Maurice Denis prized this painting and bought it back from Galerie Druet in 1918, never parting with it again.

His Life (1870–1943)

Maurice Denis was a painter, theorist, art critic, illustrator, engraver, and glass painter. He was born in Granville and began his studies at the École des Beaux-Arts and the Académie Julian in Paris in 1888. One of the founders of the Nabis ("prophets" in Hebrew), he represented the group's religious contingent, whereas Pierre Bonnard and Édouard Vuillard painted secular scenes of contemporary life. Denis's spiritual aspirations were awakened by a trip to Rome, and further reinforced by the death of his wife and favorite model, Marthe Meurier, in 1919.

A Christian painter among the Nabis

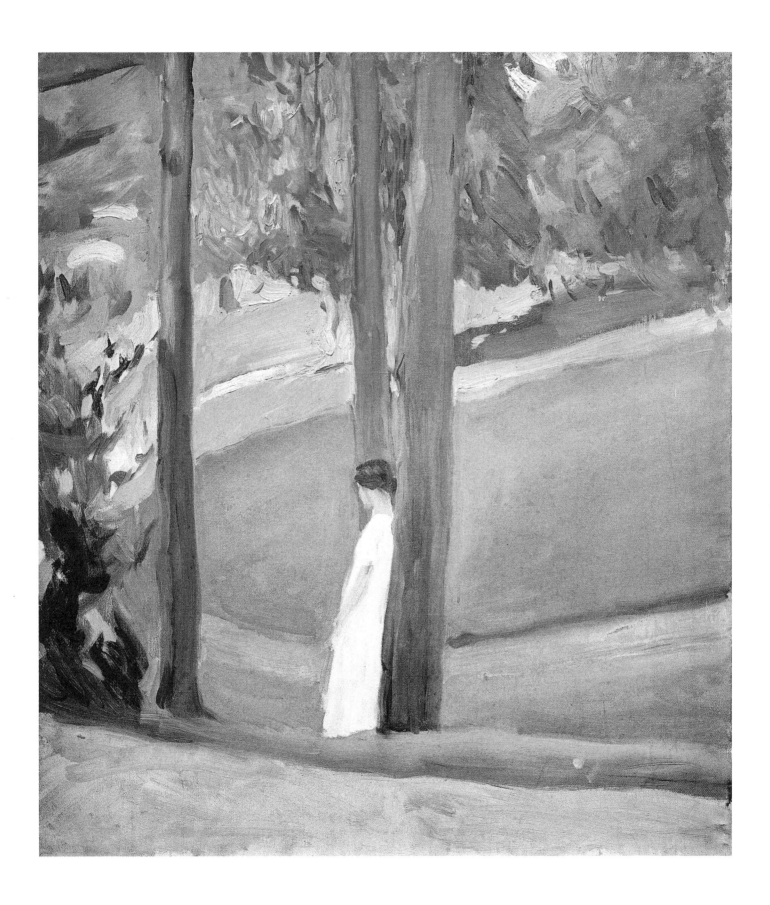

1911

Joaquín Sorolla y Bastida

Landscape in San Sebastian
Oil on canvas
3 ft. 5 in. × 3 ft. 1 in.
(104 × 94 cm)
Museo Sorolla, Madrid

Where to See His Works

Art Institute of Chicago, Chicago
Getty Museum, Los Angeles
Hispanic Society of America, New York
Musée des Beaux-Arts, Pau
Museo del Prado, Madrid
Museu de Belles Arts, Valencia
Museum of Modern Art, New York
Palais de Justice, Limoges

The Work

This painting immerses us in a peaceful vision of nature, inviting introspection. At the center of the composition, a young woman leans pensively against a tree trunk. Dressed in a simple white gown, she stands alone and somewhat isolated in this brightly hued landscape. The upper half of the canvas is flooded with sunshine and suffused with light, but the figure herself is in shadow. She is painted in profile, and we cannot discern her facial expression. The work's real subject is nature's beauty. Perhaps the girl is looking toward the sea: San Sebastian is a coastal town, and Sorolla painted it on numerous occasions. But the sea is at most an imagined presence in this work, because the composition is hemmed in by greenery on all sides. Flat expanses of color occupy the painting's middle ground. We experience a moment of solitude in the warmth of the sunlight. Sorolla painted this work in 1911 when Spain was undergoing severe political upheavals. The artist had stopped painting realistic scenes, turning to gentler views of nature and peaceful interludes of daily life. He embraced light to obscure the darkness.

His Life (1863–1923)

The Spanish painter Joaquín Sorolla y Bastida was born in Valencia, where he enrolled in the Real Academia de Bellas Artes de San Carlos at the age of sixteen. Obtaining a scholarship, he traveled to Rome, where he studied the works of the Renaissance masters and was subsequently inspired by the paintings of Velázquez in Madrid. He moved there in 1889, when his work began to be recognized internationally. He received a gold medal for *Another Marguerite* (1892), a social-realist work characteristic of his early period. But his style changed completely when he encountered impressionist works during a visit to Paris, and he began to paint plein air scenes, frequently showing families by the seaside. Abandoning his previously somber palette, he was later described as a luminist painter.

Paintings radiant with light

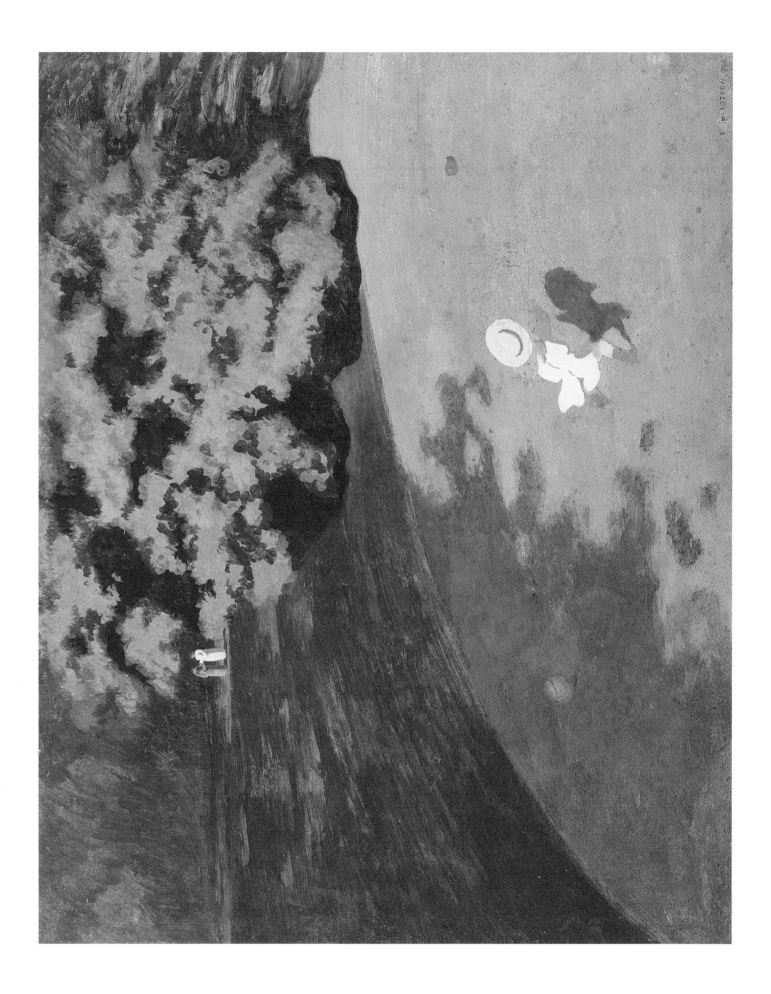

1899

Félix Vallotton

The Ball
Oil on card glued to wood
19 × 24 in.
(48 × 61 cm)
Musée d'Orsay, Paris

Where to See His Works

Art Institute of Chicago, Chicago
Fine Arts Museums of San Francisco,
San Francisco
The Metropolitan Museum of Art, New York
Musée d'Art et d'Histoire, Fribourg, Switzerland
Musée de Grenoble, Grenoble
Musée des Beaux-Arts, Quimper

The Work

This canvas has two distinct sections, depicting two separate scenes that seem to bear no relation to each other. In the foreground, a curving contour defines the work's overall structure. Patches of shadow emanate from this dividing line, and their progression into the sandy area in the foreground appears to menace a small blond child. Captured in a fleeting moment of play, he races after a little, bright red ball. Meanwhile, two distant figures seem isolated by an expanse of greenery. Only the viewer keeps a wary eye on the child, who seems to be fleeing the painter and the disquieting world of adults, hastening away from us toward the radiant world of childhood. The painting's original title is enigmatic: *le ballon* (the larger ball), almost lost in the shadows, is not the main subject. It is completely ignored by the child, who sprints ahead to catch the small red ball instead. Félix Vallotton purchased a Kodak camera the same year he painted this picture. The surviving snapshots and the two very different points of view and sections of the picture suggest that photography was a source of inspiration for the artist.

His Life (1865–1925)

Félix Vallotton was born in Lausanne. He left Switzerland at the age of sixteen to study at the Académie Julian in Paris. His early career was difficult, and financial hardship compelled him to accept commissions and execute copies of works in the Louvre by Albrecht Dürer, Frans Hals, and Jean-Auguste-Dominique Ingres, who all fascinated Vallotton. His career was truly launched when he exhibited his first wood engravings in 1891. His newfound celebrity allowed him to meet, and later join, the Nabis, and to work for the art and literary magazine *La Revue Blanche*. Vallotton became a naturalized French citizen in 1900, when he left the Nabis and began to work independently. He painted nudes and landscapes, and was also active as an illustrator, engraver, and writer. Vallotton drew inspiration from daily scenes of family life. Although he could not serve as a combatant, he nevertheless went to the front in 1917 to execute artistic commissions for the army. His work depicted landscapes devastated by war.

More than 1,700 paintings,
237 prints, 10 plays, and 3 novels

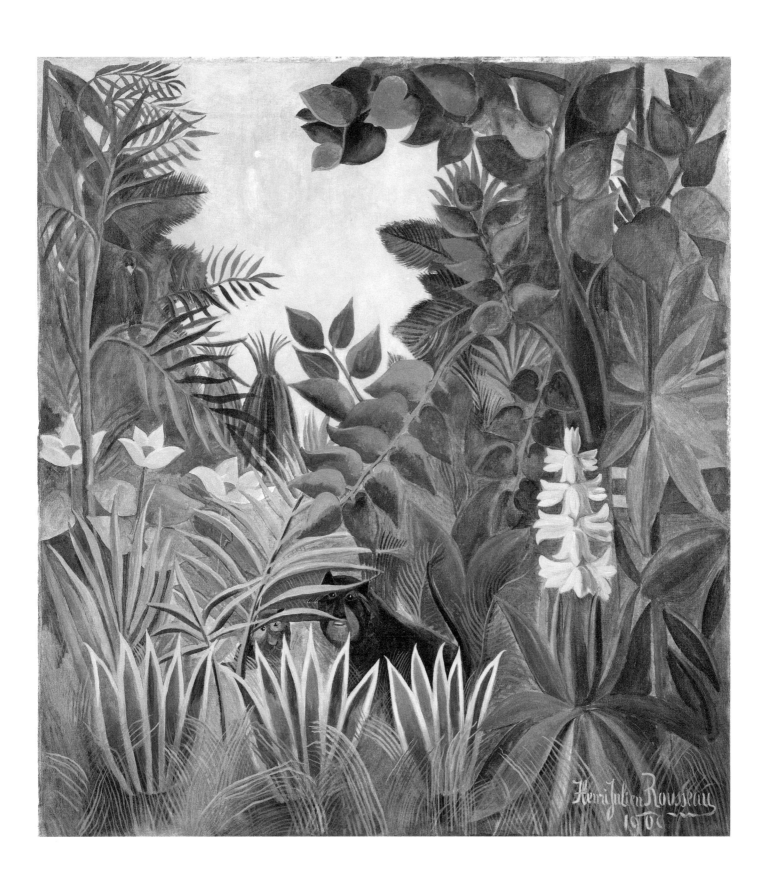

1909

Henri (Le Douanier) Rousseau

The Equatorial Jungle
Oil on canvas
4 ft. 8 in. × 4 ft. 3 in.
(1.40 × 1.29 m)
National Gallery of Art, Washington, D.C.

Where to See His Works

Art Institute of Chicago, Chicago
Centre Pompidou, Paris
Guggenheim Museum, New York
J. Paul Getty Museum, Los Angeles
Musée d'Art Naïf et des Arts Singuliers, Laval
Musée de l'Orangerie, Paris
The Museum of Fine Arts, Houston
Museum of Modern Art, New York
The National Gallery, London
Philadelphia Museum of Art, Philadelphia

The Work

Wild animals gaze out warily from the depths of a luxuriant forest. Two furry beasts, visibly curious, crouch within the foliage. Above them, a less timid bird stands erect and alert. Its body is painted in red, and it stands out more conspicuously than its companions, although its wings seem to blend into the surrounding vegetation. The observer is himself observed. Lush foliage dominates this vertical composition. The trees' long boughs bend back on themselves as they reach the upper part of the frame; seemingly arrested in their upward growth, they are beginning to invade the picture's remaining open space. Henri ("Le Douanier") Rousseau invites us into a fantastical world suffused with varied and subtle shades of green. The artist never left France, but he was able to convey a jungle's setting based on his observations in the Louvre and his visits to the greenhouses of the Jardin des Plantes and the Jardin d'Acclimatation. His strange, dreamlike settings appealed strongly to the surrealists, including André Breton and Guillaume Apollinaire.

His Life (1844–1910)

Henri Rousseau, known as "Le Douanier Rousseau," was born in Laval. He won prizes in drawing and music at the age of sixteen, but he had little interest in his studies and began work as a solicitor's clerk in Angers. In 1867, he came across accounts written by the survivors of an expedition to Mexico, and they fired his imagination. He began to work as a self-taught painter in 1870. His paintings were received with both admiration and derision when he first ventured into the art world, exhibiting in the 1886 Salon des Indépendants. The 1889 World's Fair spurred his imagination further, providing him with fresh inspiration. When Pablo Picasso and Ambroise Vollard began to buy his paintings in the early 1900s, Rousseau's "naive" art emerged into the artistic limelight. Working as a customs agent in the outskirts of Paris, Rousseau was given the nickname "Le Douanier" by the poet and writer Alfred Jarry.

*Dreamlike paintings
by an armchair traveler*

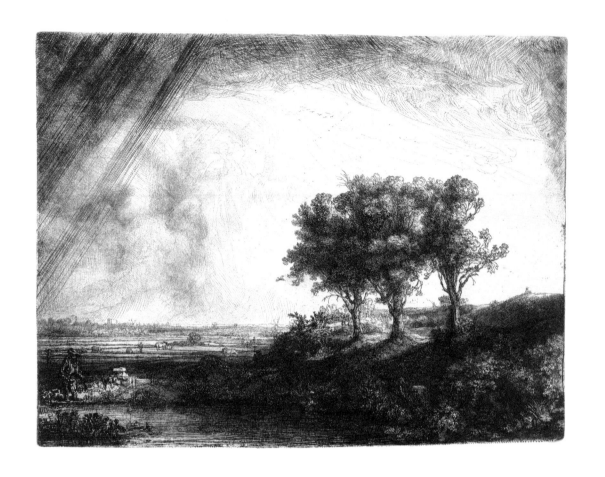

1643

Rembrandt van Rijn
Landscape with Three Trees
or *The Three Trees*
Etching, engraving, and drypoint
9 × 11½ in.
(22.6 × 29.3 cm)
Fitzwilliam Museum, Cambridge

Where to See His Works

Frick Collection, New York
The Metropolitan Museum of Art, New York
Musée des Arts Décoratifs, Paris
Musée du Louvre, Paris
Wallace Collection, London

This work is Rembrandt's largest landscape etching. Three trees stand sentinel on a low rise, and a town is visible on the horizon. The sky shows the weather shifting from sunshine to rain showers, and the work has a sense of depth that only a master of burin engraving could achieve. Figures in the landscape go about their daily lives. On the crest of a hill to the right, we note the presence of a draftsman who turns his back on the landscape and directs his attention toward something outside the frame.

Rembrandt Harmenszoon van Rijn (1606–1669) was a painter, engraver, and collector born in Leyden, in the Netherlands. After several years of apprenticeship, he opened his own workshop and was soon recognized for his portraiture. His mastery of chiaroscuro was unprecedented at the time and contributed greatly to his reputation. His vast array of work includes paintings of historic, mythological, and religious subjects.

1804

Ike No Taiga
Taigadô Gafu
Album of paintings
Color woodcut
11¾ × 7½ in.
(29.8 × 19.1 cm)
Art Gallery of New
South Wales, Sydney

Where to See His Works

Musée National des Arts
Asiatiques—Guimet, Paris
Philadelphia Museum of Art, Philadelphia

During Ike No Taiga's studies in painting, he referred to printed texts including *Jieziyuan hua zhuan* (Manual of a Mustard Seed Garden), dating from the early Qing dynasty (1644). These guides included theoretical and technical essays on painting and were generously illustrated with plates. This work comes from a manual written by Taiga himself, which was published posthumously. The different methods and techniques used by the painter to represent various characteristic features of trees are explored.

Ike No Taiga (1723–1776) was born in Kyoto. He is considered to be one of the founders of the *bunjinga* ("literati painting") or *nanga* ("southern painting") movement. Trained by highly literate monks, Taiga mastered the art of calligraphy as a child. He then studied painting and became a professional artist. He was famous in Edo around 1748 for his virtuoso mastery of finger painting. His work was influenced by both Japanese and Chinese art, as well as Western painting, which he first encountered in 1750.

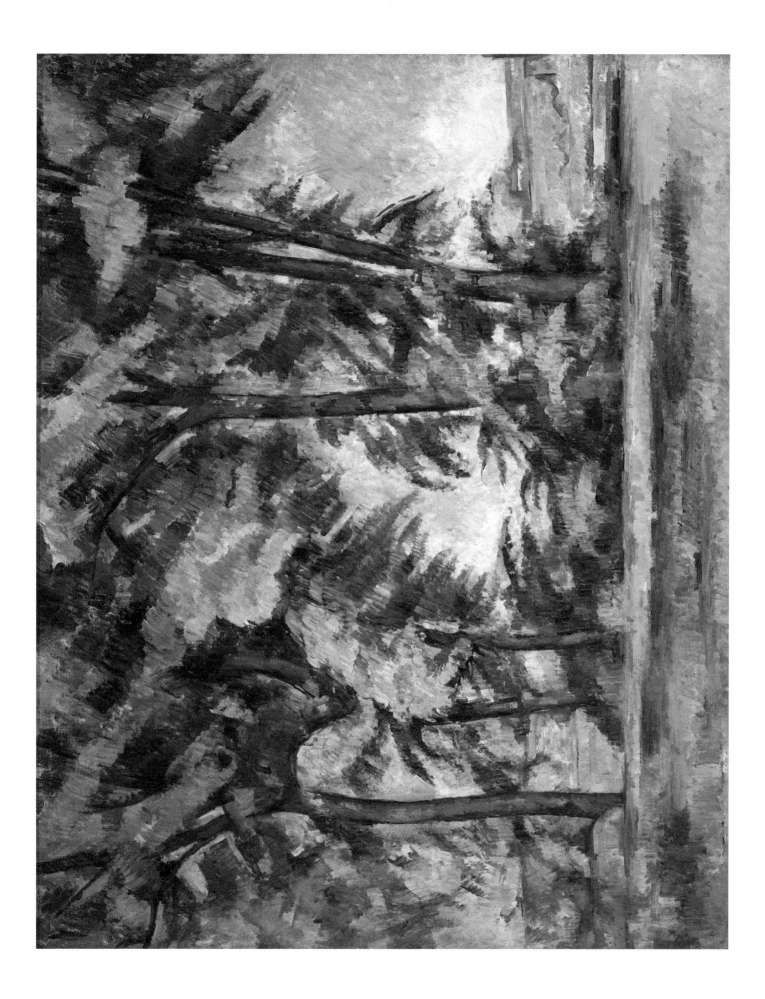

1883

Paul Cézanne

Tall Trees at the Jas de Bouffan
Oil on canvas
25½ × 32 in.
(65 × 81 cm)
The Courtauld Gallery, London

Where to See His Works

Guggenheim Museum, New York
Kimbell Art Museum, Fort Worth
Musée d'Orsay, Paris
Musée des Beaux-Arts, Lyon
Musée Granet, Aix-en-Provence
Museum of Modern Art, New York

The Work

As the title suggests, the lofty trees soar above the framed space as seen from the painter's point of view. The trees are dense, and the cool, verdant earth at their feet is sheltered from the sun. Formidable barriers, the trees allow only glimpses of the background landscape, which includes a house on a distant rise that is rendered in tones of yellow and orange. The atmosphere elsewhere in the painting seems warmer, and the dry grass evokes the heat of a Mediterranean afternoon. The flattened treatment of the sky precludes a sense of perspective but does not obscure the depth of the landscape. Brushstrokes are applied from various directions, and we can follow the movement of the painter's hand across the canvas. The artist conveys light through a large range of green tonalities—light and color are one here. In 1883, Paul Cézanne began to withdraw from impressionist circles to pursue artistic explorations in the south of France, his spiritual home. The artist worked from nature, painting in the garden of his family property in Jas de Bouffan. It was there that he began the most productive period of his career.

His Life (1839–1906)

Paul Cézanne was born to a prosperous family in Aix-en-Provence. He visited Paris in 1862, a decisive turning point in his career. Urged on by his close friend Émile Zola, he decided to abandon his law studies to become a painter. Cézanne met other artists, including Pierre-Auguste Renoir, Claude Monet, and Frédéric Bazille, and became particularly close to Camille Pissarro. However, he encountered numerous setbacks, and his work was misunderstood and rejected by the Salons. He decided to exhibit his canvases again in 1877 at the impressionist exhibition, but they received a very cool reception. Cézanne then distanced himself from the group and devoted himself to his painting, dividing his time between Paris and his native Provence. His style continued to evolve, spanning four major periods. He ultimately arrived at the synthetism that influenced future cubists (Georges Braque and Picasso) as well as Henri Matisse.

A leading figure in modern art

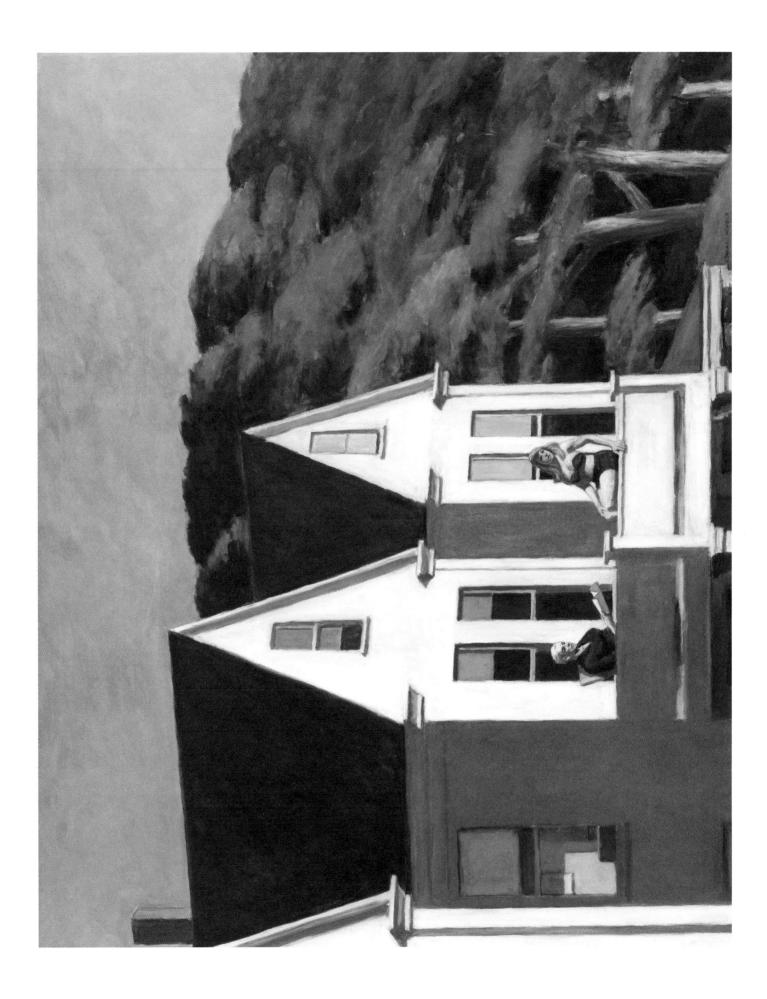

1960

Edward Hopper

Second Story Sunlight
Oil on canvas
3 ft. 3 ¾ in. × 4 ft. 2 in.
(1.01 × 1.27 m)
Whitney Museum
of American Art, New York

Where to See His Works

Art Institute of Chicago, Chicago
Brooklyn Museum of Art, New York
The Metropolitan Museum of Art, New York
National Gallery of Art, Washington, D.C.
Philadelphia Museum of Art, Philadelphia
San Francisco Museum of Modern Art, San Francisco
Smithsonian American Art Museum, Washington, D.C.
Virginia Museum of Fine Arts, Richmond

The Work

A morning like any other, a "second story." Two women are posed on a balcony, basking in the sun's restorative warmth. The rays penetrate the interior of the house, filling the room with light. One of the women, comfortably seated in an armchair, is absorbed in her reading, while the other, dressed in a swimsuit, is perched on the edge of the balcony. Their ages and poses tempt us to speculate about the nature of their relationship. Are they mother and daughter, two friends, or perhaps an allegory of youth and age? The contours are clearly delineated and the contrast between the various zones of color accentuates the composition's geometrical qualities. A second pairing in the picture strikes the viewer: two adjacent houses, virtually identical in their architecture. A dense forest fills the background, blocking the view and shutting off a row of trees. Hopper's paintings often imply enigmatic narratives. The impassive demeanor of the figures lends a dramatic intensity to his subjects. This late work demonstrates Hopper's unwavering commitment to light as an essential element of his palette. It was an equally important focus of his prints. "All I really tried to paint was sunlight on the façade of a house."

His Life (1882–1967)

Edward Hopper was an American painter, engraver, and illustrator. He did a correspondence course in drawing, before continuing his studies at the famed New York School of Art and Design in 1900. He traveled throughout Europe and explored Paris, steeping himself in French artistic movements, particularly impressionism. When he returned to New York, a publicist hired him as a designer and illustrator, and this activity was his sole source of income until 1925. His career did not really take off until he was forty-two years old. His style was distinctive, and the framing of his compositions shows the influence of photography. His paintings are pervaded by an aura of isolation, with pensive figures pondering America's sense of disillusionment.

Paintings of an almost cinematic realism

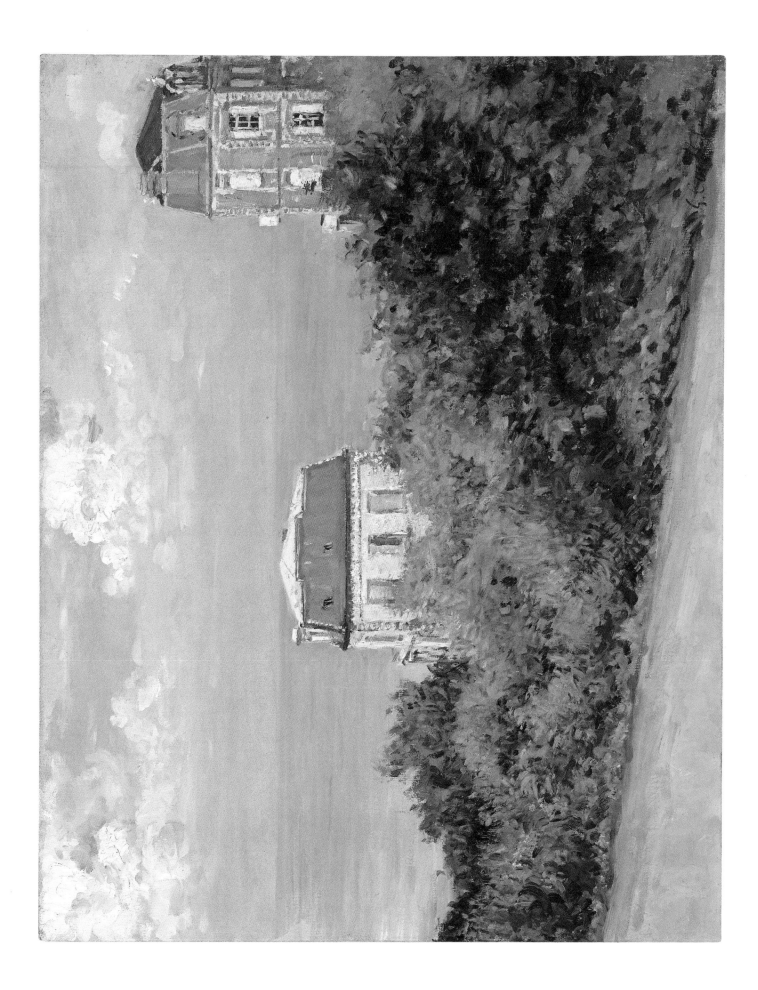

1880

Gustave Caillebotte

Villas at Villers-sur-Mer
Oil on canvas
25 ½ × 32 in.
(64.8 × 81.3 cm)
Private collection

Where to See His Works

Fondation Bemberg, Toulouse
Milwaukee Art Museum, Milwaukee
Musée d'Orsay, Paris
Musée des Beaux-Arts, Rennes
Museum of Fine Arts, Boston
Museum of Fine Arts, Houston

The Work

The impressionists were irresistibly drawn to Normandy; the region had much to recommend it. Far from the noise and clutter of Parisian studios, an artist could fully experience the countryside and embrace natural beauty. In this painting, Gustave Caillebotte gives us an elevated perspective, viewing the scene from a hill overlooking a panoramic landscape. The painter stands across from an overgrown woodland, with the sea visible in the distance. The weather seems changeable; the colors used to describe the agitation of the clouds mingle with the more tranquil hues of the sea. A rainstorm may be imminent, or perhaps a shower has just refreshed the earth. In the middle ground, we see the colorful facades of two bourgeois villas typical of the region. Caillebotte has abandoned the solitude of a big city. Far from Paris, he paints the contentment he has rediscovered and experienced through nature.

His Life (1848–1894)

Gustave Caillebotte was a Parisian painter, collector, and artistic patron. After gaining a law degree, he entered the École des Beaux-Arts in 1873. His father left him a substantial real-estate fortune that allowed him to establish his studio and develop his career as a painter. His subjects included the daily life of the Parisian bourgeoisie, his own milieu; he also painted outdoor scenes from unconventional points of view. Closely allied with the impressionists, he helped to organize their first exhibition in 1874, and showed his own work with them from 1876 until 1882. He later distanced himself from the movement. He was a close friend of the critic Edmond Duranty; Duranty's manifesto *The New Painting* (1876) alluded to various features of Caillebotte's work, particularly his realistic depiction of daily life and the individual's role in contemporary society. Caillebotte purchased many paintings during his lifetime, providing support to his impoverished artist friends. He bequeathed his collection to the State, and its masterpieces are currently on display in many public collections.

Bold compositions and views from a Parisian painter

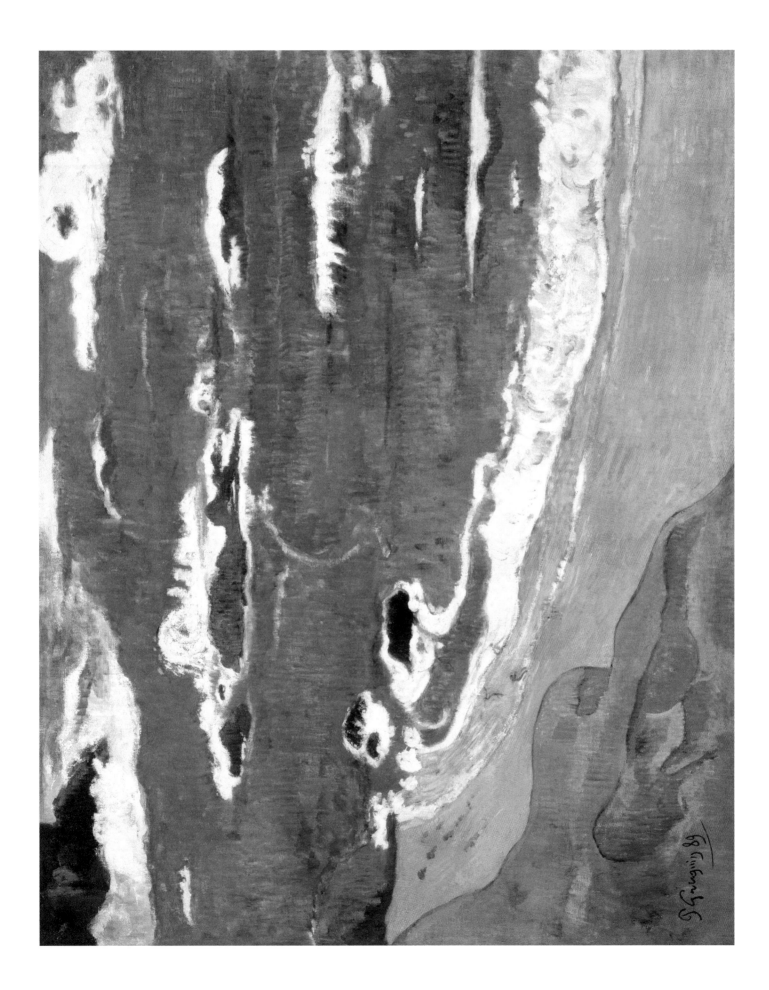

1889

Paul Gauguin

Beach at Le Pouldu
Oil on canvas
28 ¾ × 36 ¼ in.
(73 × 92 cm)
Private collection

Where to See His Works

The Courtauld Gallery, London
J. Paul Getty Museum, Los Angeles
Musée Albert-André, Bagnols-sur-Cèze
Musée des Beaux-Arts, Orléans
Musée des Beaux-Arts, Rennes
Museum of Fine Arts, Boston
Museum of Modern Art, New York

The Work

We look down from a vertiginous height, peering over a cliff that looms above the beach and shoreline. A narrow sliver of grass in the foreground gives us a tenuous purchase above the void, intensifying the sense of precariousness. Irregular swells heave themselves against the rocks; they emerge from the waters that cover three-quarters of the composition. Ranging from gray to blue, green to purple, these hues transport us into the seascape below. The sea's virulent power precludes a seaside promenade; it is better observed from a safe distance. Gauguin was influenced by the prints of the Japanese artist Hokusai, and strove to apply Japanese techniques to convey the effects of the waves. He created this canvas in the same year that the World's Fair opened in Paris, but Gauguin was not invited to display his work there. In response, he and several of his artist friends abandoned the bustle of Paris and retreated to the tranquility of Pont-Aven. Gauguin soon isolated himself further in Pouldu, a fishing and farming village he had visited since 1886. He moved on again in 1890, with many completed canvases and lasting memories of the town's distinctive setting.

His Life (1848–1903)

Paul Gauguin was a Paris-born painter, sculptor, and ceramist. He became acquainted with the collector Gustave Arosa, a close friend of Camille Pissarro, who urged him to pursue an artistic career. In 1878, Pissarro suggested that Gauguin display his works in impressionist exhibitions. After that, Gauguin embarked on the traveling that would continue throughout his lifetime. During his stay in Pont-Aven he adopted the technique of synthetism, featuring two-dimensional areas of solid color, simplified forms, and separation of picture planes. That same year, 1888, he visited Van Gogh in Arles, where the two artists had a notorious falling out. Gauguin sailed for Tahiti in 1891 in search of a more "primitive" artistic expression. He returned to Paris a few years later and attempted to sell his works at Paul Durand-Ruel's gallery. Faced with widespread incomprehension and rejection, Gauguin soon returned to Tahiti, where he painted *Where Do We Come From? Who Are We? Where Are We Going?* in 1897. This work expressed the anguish he experienced throughout the remainder of his life.

A painter in exile, inspired by the exotic

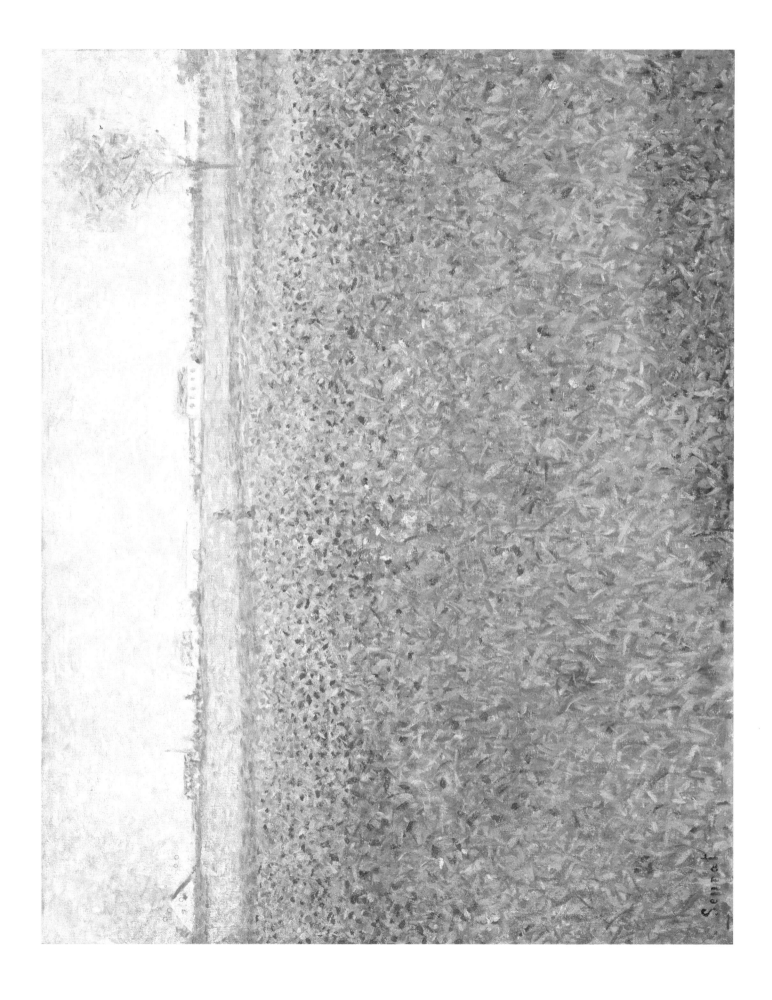

1886

Georges Seurat
Alfalfa, Saint-Denis
Oil on canvas
25½ × 32 in.
(65 × 81.3 cm)
Scottish National Gallery, Edinburgh

Where to See His Works

Barnes Foundation, Philadelphia
Dallas Museum of Art, Dallas
Musée d'Art Moderne, Troyes
Musée de l'Annonciade, Saint-Tropez
The National Gallery, London
Palais des Beaux-Arts, Lille

The Work

A field blooming with poppies, alfalfa, and other wildflowers lies before us. The artist juxtaposes tiny brushstrokes directly onto the canvas, rather than mixing pigments on his palette. The field occupies three-quarters of the painting's surface. It may take a moment of study for our eyes to blend the colors. A darker area in the foreground is rendered by tiny dots in shades of green that are in turn highlighted with brighter touches of color. We might imagine the painter comfortably seated beneath a tree with his easel before him. A prominent horizontal line traverses the painting; above it a small vertical form appears, and the composition converges toward this point. In the distance, the colors of the houses echo those of the sky. This canvas demonstrates a rigorous painting technique. Seurat was working in an era when there was revolutionary scientific research into the phenomenon of color. The artist was fascinated by these theories, and became an adherent of the law of "simultaneous contrast" proposed by the chemist Michel-Eugène Chevreul. He employed fragmented dots of pure pigment, according to the practice of subtractive color synthesis. The separation of the colors on the canvas enhanced the luminosity of his works, as the juxtaposed hues intensify each other's impact. Seurat painted this landscape two years before his first monumental compositions *Bathers at Asnières* and *A Sunday on La Grande Jatte.*

His Life (1859–1891)

Georges Seurat came from a middle-class Parisian family and began his artistic career in the traditional way: he studied under the painter Henri Lehmann at the École des Beaux-Arts, where he enrolled in 1878. Seurat aspired to a new concept of painting, and scientific studies played a decisive role in the evolution of his style. Contemporary studies by Michel-Eugène Chevreul and Ogden N. Rood were the basis for his pointillist technique. Seurat was part of a new generation of young painters who questioned trends in impressionism, with the result that Monet and Renoir actually withdrew their work from the group's last exhibition in 1886. Although his career was brief, Seurat had a significant influence on his contemporaries, and on the evolution of modern painting.

*Depicting the landscape
with dashes of color*

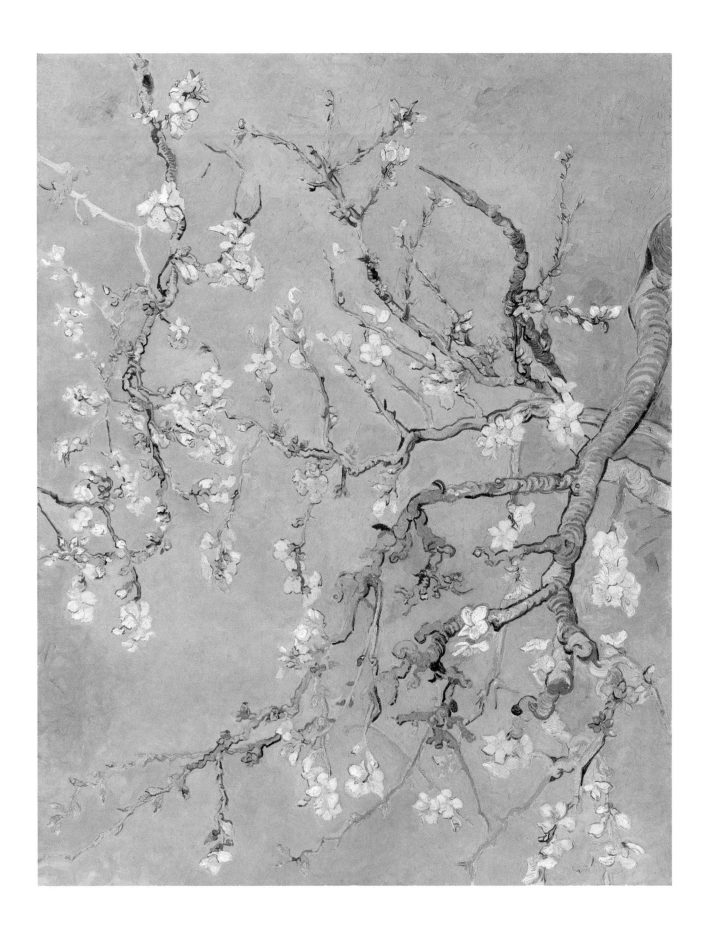

1890

Vincent van Gogh

Almond Blossom
Oil on canvas
28 ¾ × 36 ¼ in.
(73.3 × 92.4 cm)
Van Gogh Museum, Amsterdam

Where to See His Works

Art Institute of Chicago, Chicago
The Courtauld Gallery, London
Fondation Vincent van Gogh, Arles
Guggenheim Museum, New York
The Metropolitan Museum of Art, New York
Musée d'Orsay, Paris
Museum of Modern Art, New York
The National Gallery, London
National Gallery of Art, Washington, D.C.
Palais des Beaux-Arts, Lille
Rijksmuseum Kröller-Müller, Otterlo

The Work

Flowering almond branches bloom against a heavenly blue background rendered with overlapping brushstrokes. The branches are viewed from beneath, without any roots or severed stumps, and occupy the entire picture plane. The buds are mostly open, heralding the first flowers to bloom as winter draws to an end. Delicate whites and pinks stand out radiantly against the background. Black lines reminiscent of Chinese ink drawings delineate the details and accentuate the perspective and the draftsmanship. Van Gogh's technique is very different from the rapid brushstrokes of impressionism; he embraced the flat areas of color and distinct lines that are typical of Japanese art. The motif of a bough seemingly suspended in space shows the influence of *ukiyo-e* ("images of the floating world"), which Van Gogh had studied extensively. He purchased six hundred Japanese prints from the art dealer Siegfried Bing in Paris between 1886 and 1887. "In the light of the South, everything becomes Japanese," Van Gogh wrote to his brother Théo. He painted this picture for Théo's newborn son while hospitalized in an asylum in the south of France.

His Life (1853–1890)

Vincent van Gogh was a Dutch artist who began studying art in the Goupil Gallery in The Hague when he was sixteen. Visiting Paris, he discovered the paintings of Jean-Baptiste-Camille Corot and Jean-François Millet, whom he greatly respected. Initially convinced that he had a vocation for the ministry like his father, he studied theology, but he soon abandoned this pursuit. In 1880, Van Gogh took up oil painting and studied drawing in Brussels. He executed a series of sketches and realist portraits in a somber style from 1883 until 1885. In Paris he met the impressionists and formed friendships with Gauguin, Seurat, and Pissarro. Van Gogh worked with them and did his own research on color. In Arles, he was captivated by the light of Provence, which inspired his canvases with their swirling brushstrokes. The artist, who had a long history of mental illness, committed suicide in July 1890. He is now considered one of the greatest artists of the nineteenth century, although he only sold one picture during his lifetime.

Vivid colors and tormented brushstrokes

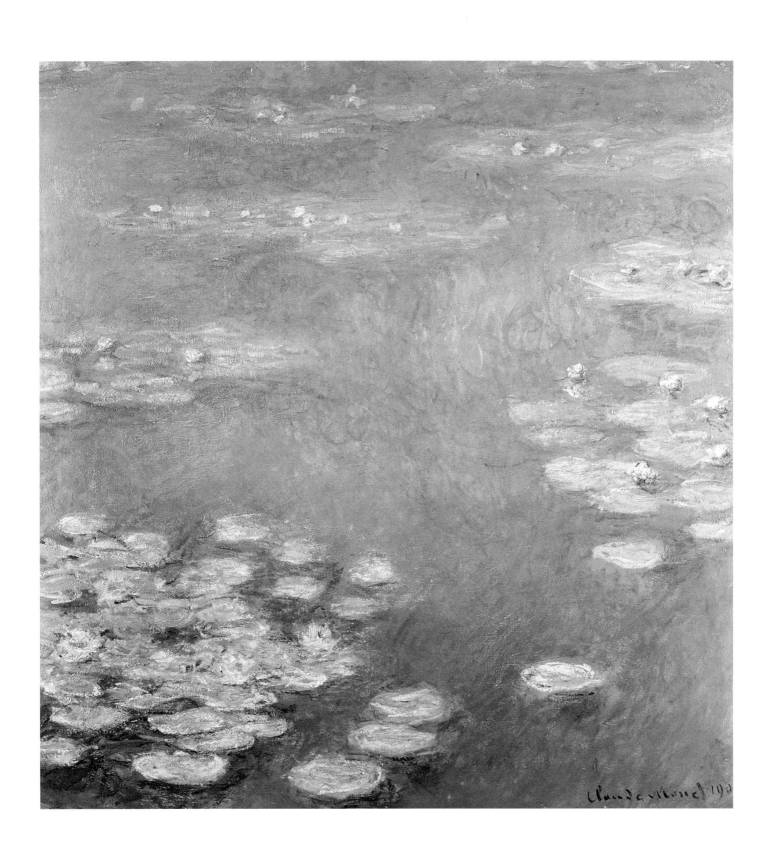

1908

Claude Monet

Water Lilies at Giverny
Oil on canvas
36 × 35 in.
(92 × 89 cm)
Private collection

Where to See His Works

Art Institute of Chicago, Chicago
Guggenheim Museum, New York
The Metropolitan Museum of Art, New York
Musée d'Art Moderne et
Contemporain, Saint-Étienne
Musée d'Orsay, Paris
Musée de l'Orangerie, Paris
Musée des Beaux-Arts, Caen
Musée des Beaux-Arts, Rouen
Museum of Modern Art, New York
The National Gallery, London
National Gallery of Art, Washington, D.C.
Palais des Beaux-Arts, Lille
Philadelphia Museum of Art, Philadelphia
Walters Art Museum, Baltimore

The Work

An ephemeral moment is captured as the natural elements on the surface of the canvas converge. Floating on the blue water of the pond, water-lily flowers blend with the aqueous hues. Shadows are rendered in bluish tonalities rather than black, and the shades of the lily pads overlap with the light resonating across the canvas. Monet freed painting from its representational role. The artist's palette is multisensory, its colors translating into sensation. In the center and upper section of the canvas we can discern traces of the brush Monet used to depict this aquatic world. Swirling vertically, the brushstrokes reflect the painter's haste to express his emotions as he viewed the scene. The work is composed and structured as if it is an undifferentiated part of a greater whole. Water lilies were among Claude Monet's signature subjects, and he painted them more than two hundred and fifty times in his "water garden." This artistic laboratory, which he began to develop in earnest in 1893 for his home in Giverny, reminds us of how Japanese art and culture fascinated and influenced the impressionists.

His Life (1840–1926)

Painter Claude Monet was born in Paris and grew up by the sea in Le Havre. In 1859, encouraged by Eugène Boudin, he applied to the École des Beaux-Arts in Paris, but was admitted to the Académie Suisse instead. Following his military service, he met his future acolytes Pierre-Auguste Renoir, Frédéric Bazille, and Alfred Sisley, like-minded artists who shared his vision of painting. He emphasized the mastery of variations in light in landscape painting and offered a new approach to the use of color. Monet exhibited for the first time in the 1865 Salon de Paris, before the impressionists organized their own exhibition in 1874. He settled in Giverny at the age of forty-three. Monet painted canvases in series, studying the effects of light on a variety of subjects, including his *Poplars* and *Haystacks* (1891) and *Rouen Cathedral* (1892–94).
By the end of Monet's life, the artistic vanguard was turning toward new challenges, but he remained a free spirit who continued to work on an imposingly large scale.

The fleeting impression of a moment in nature

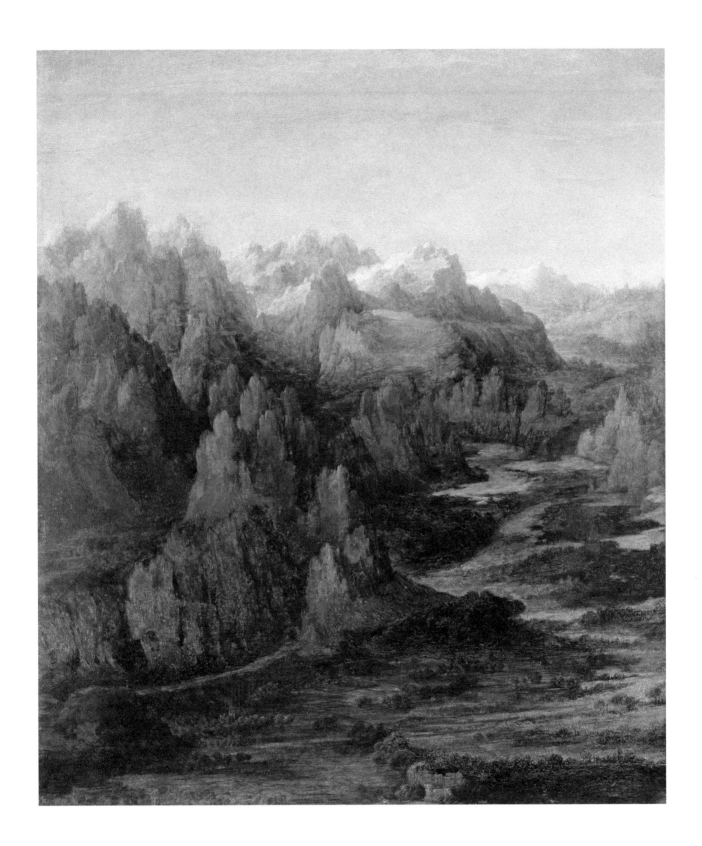

1530

Albrecht Altdorfer
Mountain Range
Oil on wooden panel
25¼ × 22 ¼ in.
(64.4 × 56.7 cm)
Tokyo Fuji Art Museum, Tokyo

Where to See His Works

Alte Pinakothek, Munich
J. Paul Getty Museum, Los Angeles
Museo Nacional Thyssen-Bornemisza, Madrid
The National Gallery, London
National Gallery of Art, Washington, D.C.

The Work

Here we see the vastness of nature and its awe-inspiring, precipitous verticality. The mountains seem to float above the valley below. This impression is reinforced by the aerial perspective that recalls the sfumato effects of Leonardo da Vinci's landscapes; it is a method of applying paint that envelops the subjects in a misty atmosphere. Contours are imprecise and blurred by successive layers of washes and glazes. The painter allocates only a small portion of the panel to the sky, but it is enough to show the horizon and create a sense of perspective. Nature seems brooding—almost threatening—but a light-filled clearing in the distance alters this impression. Albrecht Altdorfer gave landscape painting pride of place in his oeuvre. His views are devoid of human presence, an anachronistic reminder of the work of nineteenth-century German romantic artists. The poetic and lyrical landscape depicted here is the painting's subject, not merely its background.

His Life (c. 1480–1538)

Albrecht Altdorfer was a German draftsman, painter, engraver, and architect. Even his earliest work demonstrates his energy and powerful sense of color. Between 1508 and 1510, he used the technique of "parallel striations" to unify all his compositions. Altdorfer later altered his style, and his Saint-Florian altarpiece shows greater expressivity, with the figures standing out against the architectural background. He once again demonstrated his talent as a colorist in 1528 when he executed *The Battle of Alexander at Issus*, a very large canvas commissioned by Duke William IV of Bavaria. The artist later adopted the new pictorial effects of the Renaissance. He is considered to be a leading exponent of the golden age of southern German painting at the beginning of the sixteenth century, and one of the foremost representatives of the Danube school.

A romantic painter of the Renaissance

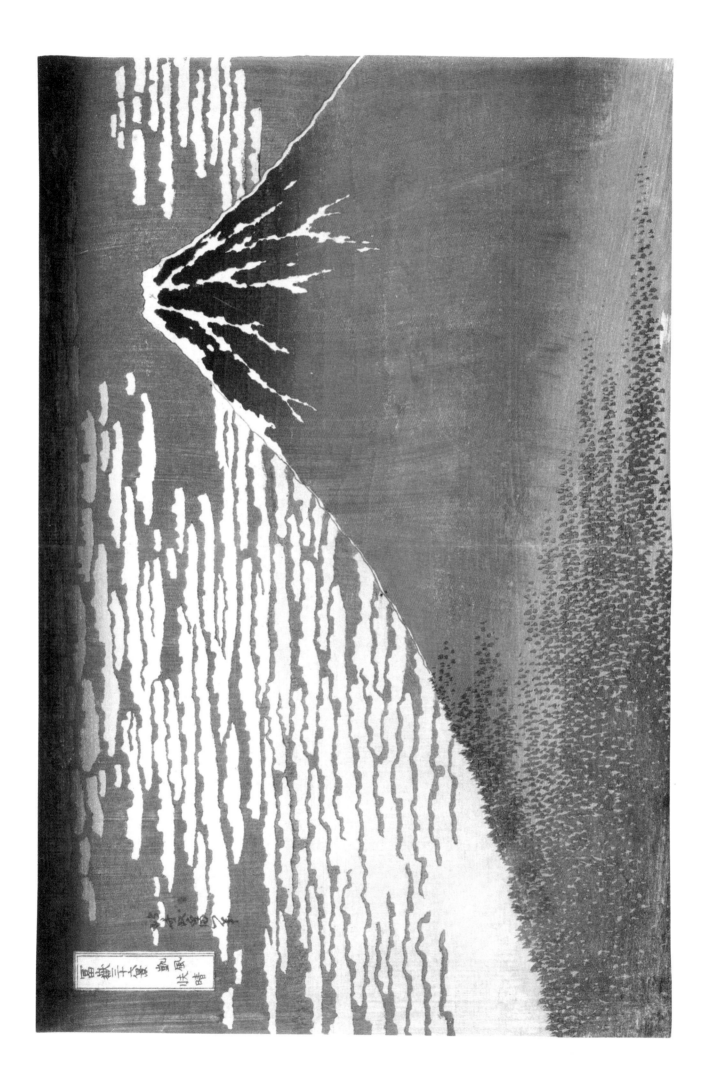

1831

Hokusai

Mount Fuji in Clear Weather (Red Fuji)
Print
10 × 11¾ in.
(25.1 × 37.2 cm)
Private collection

Where to See His Works

Barnes Foundation, Philadelphia
British Museum, London
Musée des Beaux-Arts, Rennes
Musée Gustave Moreau, Paris
Musée National des Arts
Asiatiques—Guimet, Paris
Smithsonian Institution, Washington, D.C.

The Work

A red Mount Fuji looms before us in all its majesty. The tiny trees indicated by delicate brushstrokes at the base accentuate the massive presence of the sacred mountain. The colors are graduated, with the darkest hues at the summit, where the view of the clouds is almost obscured. At this altitude, the snow remains unmelted by the warmth of the sun. Clouds emerge from the left side of the composition and appear to crumble against the backdrop of the blue sky. Paradoxically threatening and soothing, nature and its immutable laws harmonize in this work. It is one of thirty-six prints executed by Hokusai between 1831 and 1833. They depict Mount Fuji from various points of view, and their dynamic perspectives and compositions demonstrate the artist's mastery of Western artistic techniques. He made this series, *One Hundred Views of Mount Fuji*, between 1834 and 1849. When Japan was opened to the West in 1853, European artists in turn discovered Hokusai's work and were instantly captivated.

His Life (1760–1849)

Tokitarō Katsushika Hokusai was a draftsman, painter, and theorist born in Edo (Tokyo). At the age of nineteen, he adopted the name Shunrō while in the workshop of Katsukawa Shunshō. His delicate early works depicted scenes of the *ukiyo-e* ("images of the floating world"). The artist changed his pseudonym when he adapted and updated his style (he had some thirty styles in the course of his career). He experienced his first success in the late eighteenth and early nineteenth centuries with a vast output of books featuring almost 13,500 plates. He introduced elements from Dutch engravings and other Western art into his work, including perspective and unconventional points of view. Hokusai was equally gifted in his decorative mastery of color, revealing its contrasts and harmonies, and he was a master draftsman.

A life devoted to artistic research and observation

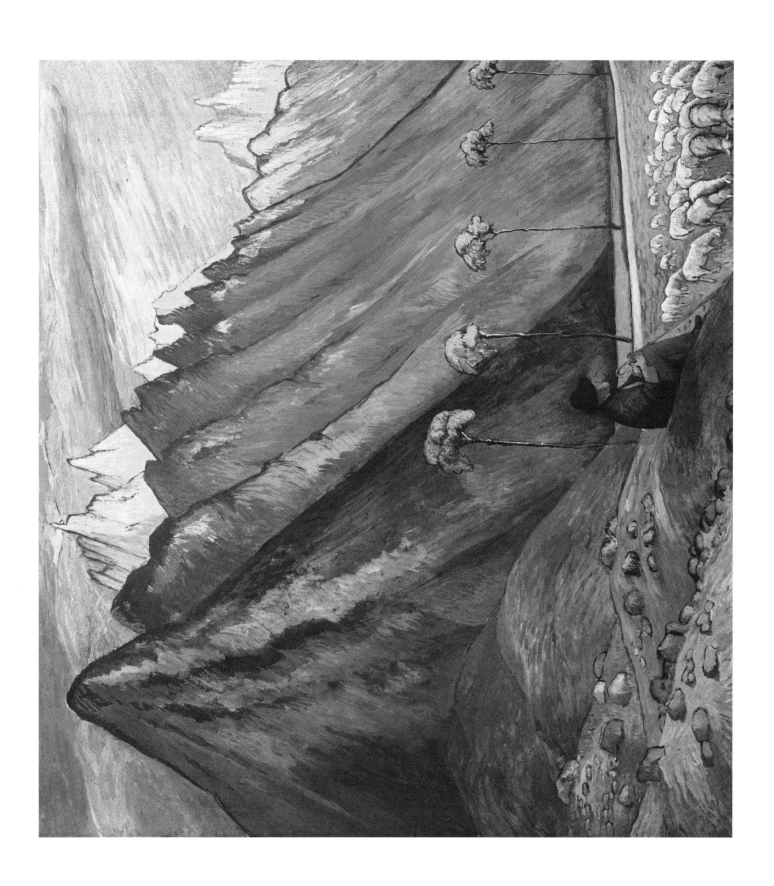

1922

Marianne von Werefkin

Evening of One's Life
Watercolor on board
28 ¼ × 25 ½ in.
(72 × 67.5 cm)
Museo Communale d'Arte Moderna,
Ascona

Where to See Her Works

Marianne von Werefkin Foundation, Ascona
Pinakothek der Moderne, Sammlung Moderne Kunst, Munich
Schlossmuseum Murnau, Murnau am Staffelsee, Germany

The Work

Towering mountains loom abruptly before us, reflecting the incandescent glow of the setting sun, which is beyond our view. An elderly shepherd contemplates the scene, seated by a steep pathway scattered with stones. He tranquilly observes the natural splendor of the scene while his flock grazes lower down the slope. The landscape extends beyond a path punctuated by a few spindly trees. The colors are so vivid that they seem to shimmer and shift if we turn our eyes away. The same astonishing brushwork appears in the sky, lighter and ethereal in the right corner with the lingering rays of the setting sun. Marianne von Werefkin painted many canvases featuring the iconographic themes of Ascona's paths and mountains, showing men and women engaged in their everyday rural tasks. The powerful expressivity of this work is a testament to the painter's sincerity. Her composition and her colors combine to express complete emotional openness.

Her Life (1860–1938)

Marianne von Werefkin was born into an aristocratic Russian family. A gifted student, she trained with Ilya Répine, an important Russian realist painter. Von Werefkin's talent earned her the soubriquet of the "Russian Rembrandt." Married to the artist Alexej von Jawlensky, she put her own career on hold for a decade. She believed that her status as a woman impeded her ability to win critical recognition and chose to promote her husband's work instead of her own. The couple moved to Munich in 1896, and they were soon joined by Wassily Kandinsky, a leader of the avant-garde. Von Werefkin resumed painting in 1906 and thereafter adopted an expressionist style reflecting the influence of the Pont-Aven school. In 1909, she helped establish the New Association of Artists in Munich, and later the Blaue Reiter group. As a Russian citizen, Von Werefkin took refuge in Switzerland in 1918 and continued to paint, although she lived in straitened circumstances.

*Depicting how the soul perceives
what the eye cannot see*

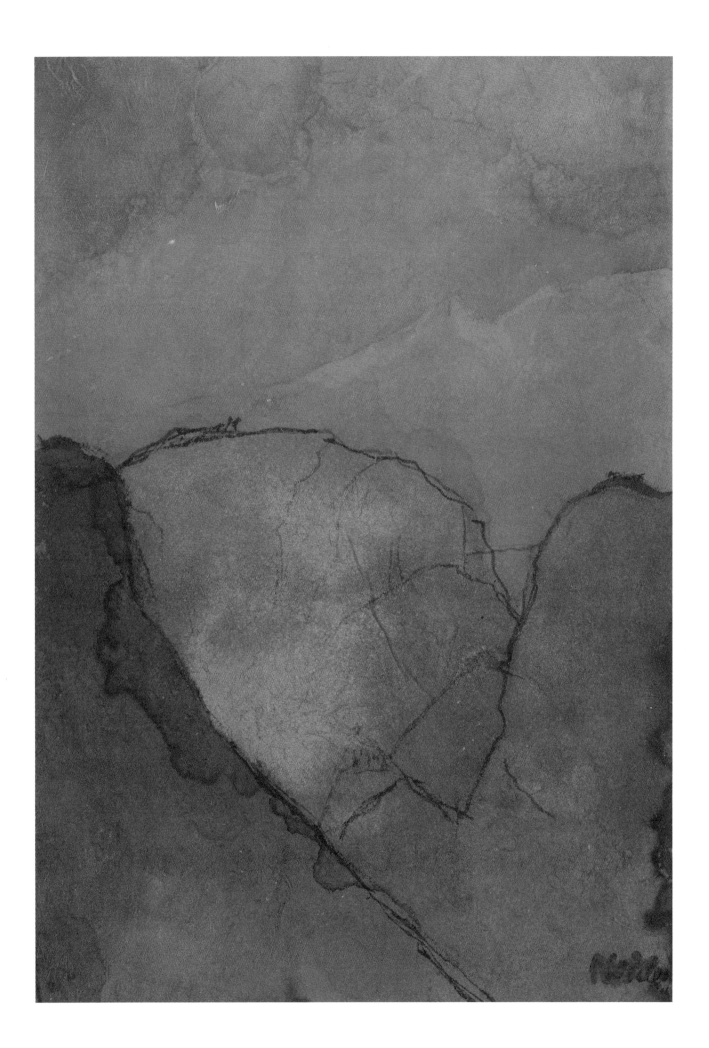

1938–45

Emil Nolde

Mountain and Sky
Watercolor on paper
8 ½ × 6 in.
(21.5 × 15.2 cm)
Private collection

Where to See His Works

Art Institute of Chicago, Chicago
Kunstmuseum, Basel
Los Angeles County Museum of Art, Los Angeles
Museo Nacional Thyssen-Bornemisza, Madrid
Museum of Modern Art, New York
Pinakothek der Moderne, Munich
Sprengel Museum Hannover, Hanover

The Work

Only the most intense colors remain visible—all the others seem to have been swallowed up by the paper. The inks blend with each other, spreading into a variety of forms. This watercolor seems to contemplate the endlessly repeated departure of sunlight as evening falls. The setting rays tint the mountain as well as the sky, heightening contrasting effects as the light disappears from view. Landscape becomes theater, and the artist superimposes compositional elements using gouache and ink. Although we are almost overwhelmed by the technical handling of the paint, these colors are very close to those created by nature. Nolde painted more than 1,300 watercolors between 1938 and 1945, referring to them as "unpainted pictures." They were produced during a dark period when the Nazis condemned and confiscated his work. These were "unpainted pictures," in part because they were officially hidden from the audience's gaze; they communicate a vision of reality that is heightened by the artist's expressionist brushstroke.

His Life (1867–1956)

Emil Hansen, known as Emil Nolde, was a German painter, engraver, and watercolorist. After training as a cabinetmaker, he gained admission to the School of Applied Arts in Karlsruhe in 1888, and was then hired by a furniture factory in Berlin. Nolde began to earn his living as an artist, working as an illustrator for the review *Jugend*. He traveled to Paris where he discovered impressionism and the paintings of Édouard Manet, who became a major influence on his work. His handling of color is distinctive. Intense and expressive, he briefly affiliated himself with the German Die Brücke movement in 1906. But the artist had a solitary bent and soon distanced himself from the group. During Germany's darkest period, Nolde was confronted by official censure despite his patriotism and acceptance of the regime. His works were confiscated and destroyed. Following the end of the war, he returned to his early sources of inspiration, drawing on cosmic and religious themes, and finally resumed watercolor painting in 1955.

*A blaze of color
on watercolor paper*

1922

Georgia O'Keeffe

Lake George
Oil on canvas
16¼ × 22 in.
(41.3 × 55.9 cm)
San Francisco Museum
of Modern Art, San Francisco

Where to See Her Works

Brooklyn Museum, New York
Centre Pompidou, Paris
Georgia O'Keeffe Museum, Santa Fe
High Museum of Art, Atlanta
The Metropolitan Museum of Art, New York
Museum of Modern Art, New York
Whitney Museum of American Art, New York

The Work

The water is dead calm. Not a single wave disturbs the tranquil waters of Lake George. The atmosphere is misty and silent. There is no detail—only simple blocks in soft shades of blue. A long horizontal line divides the composition in two, and symmetry prevails. The mountain, suggested with the utmost economy of detail, is reflected in the water. Painted in cool colors, the vista is almost lunar. Luminosity suffuses the entire canvas and envelops us in tranquility, lulling us into a meditative state. The harmonious fusion of the various elements is so complete that viewers can amuse themselves by changing the picture's orientation to make it even more abstract. O'Keeffe's relationship with the photographer Alfred Stieglitz began in 1922, when he invited her to his family summer home in the southeastern Adirondacks. Struck by the beauty of these landscapes, O'Keeffe created a series of paintings depicting the landscape in a "precisionist" style that reduced forms to their essentials.

Her Life (1887–1986)

Georgia O'Keeffe, an oil painter and watercolorist, was born in Sun Prairie, Wisconsin. She studied at the Art Institute of Chicago and the Art Students League of New York. Her early works were described as "organic abstraction," and were influenced by the French avant-garde and the compositions of Wassily Kandinsky. She was introduced to the photographer Alfred Stieglitz, who was impressed by her charcoal drawings and offered to exhibit them in his gallery. Their artistic collaboration inspired her approach to pictorial composition, which combined elements of abstraction and figuration. Well-known examples include a series of flower paintings in which the motif occupies the entire pictorial space, remote from any context. From 1925 until 1930, the two artists lived together in New York, where O'Keeffe painted cityscapes and skyscrapers. After several extended visits to New Mexico, and the death of Stieglitz in 1946, she settled there permanently in 1949. She concentrated on landscapes that evoke a sense of spiritual communion with the natural environment.

*A pioneer of modern
American art*

1968

Jean Paul Lemieux

The Express
Oil on canvas
3 ft. 3¾ in. × 6 ft. 8¾ in.
(1.01 × 2.04 m)
Musée National des Beaux-
Arts du Québec, Quebec

Where to See His Works

Musée d'Art Contemporain, Montreal
National Gallery of Canada, Ottawa

The Work

Snow engulfs everything, even the railroad tracks that slash through the white landscape. A dark form emerges in the distance, as a locomotive heads toward us. The snow will be cleared away by the speed of its passage. Stripped of all identifiable features, the vast space is immersed in silence, and time stands still. Lemieux entered his "classic" artistic period in the 1950s, and landscapes were typical of his work at that time. The utter simplicity of his canvases reinforces the power of the dominant linear elements. The elongated horizontal format of these works suggests the influence of cinema on his work. His palette is limited to a few pigments of ocher, olive green, black, and white, and he deploys these halftones to conjure up his memories. These wintry Canadian vistas evoke the passage of time and express the artist's sense of solitude. The theme of a passing train began to appear frequently from 1956, and Lemieux relates the motif to the symbolism of elapsing time. "We have the time to see the landscape coming, watch it appear and extend before us, and then vanish into the distance."

His Life (1904–1990)

Jean Paul Lemieux was a Quebecois painter, illustrator, professor, and art critic. He joined the atelier of an impressionist painter in Montreal in 1925. He continued his training at the École des Beaux-Arts de Montréal until 1934, and taught there from 1937 to 1965. His career comprised three major periods. The first, commonly referred to as "naive" or "primitive," was in the 1940s. It was followed by a "classical" interlude from the early 1950s until the late 1970s, concluding with an "expressionist" period whose paintings evoke the disquieting atmosphere of Edvard Munch's works. He also produced numerous illustrations for novels and anthologies. In 1967, Lemieux executed a mural for the Confederation Centre of the Arts in Charlottetown and painted a number of political and royal portraits.

*Silently painting
the concept of time's passage*